LADY AGNEW, 1892-3

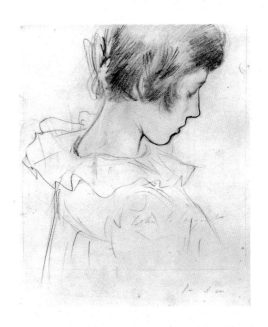

THE AGE OF ELEGANCE
The Paintings of John Singer Sargent

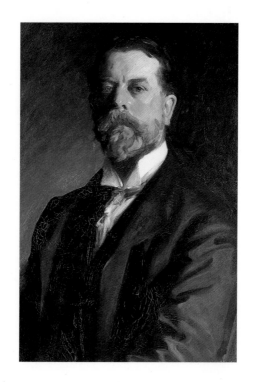

SELF-PORTRAIT, 1907

In 1926, the year after the death of John Singer Sargent, the famous critic Roger Fry wrote: 'Sargent's figure seemed to loom in colossal proportions over the social history of the last forty years.' Whether Sargent would have seen himself as a social chronicler is another question. He painted because he wanted to and he painted society portraits because they paid. He quickly earned a reputation as a fashionable painter who knew all the right people and was accorded their respect.

Luckily for Sargent the second half of the nineteenth century lent itself to being painted. The figures in Sargent's portraits all have a dignity and a sense of elegance, whether they are glamorous heiresses or brooding industrialists. It is easy to imagine these figures spending their nights at the opera or theatre and their days receiving callers or driving out in their carriages. This is the era recorded on paper by Henry James. Extracts from his novels convey the same sense of elegant grandeur.

Although this book concentrates simply on Sargent's portrait work, it is only one side of his oeuvre. When he died, a childhood friend suggested that the conclusion of a would-be biographer should be 'He painted'. It would have made a fitting obituary for a man who had devoted his life to art.

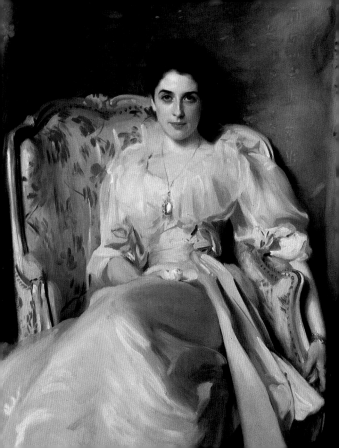

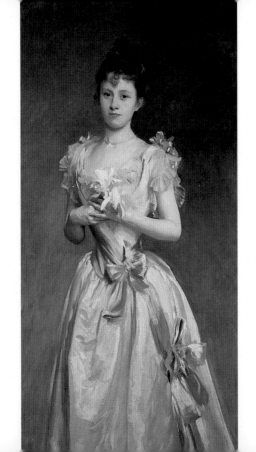

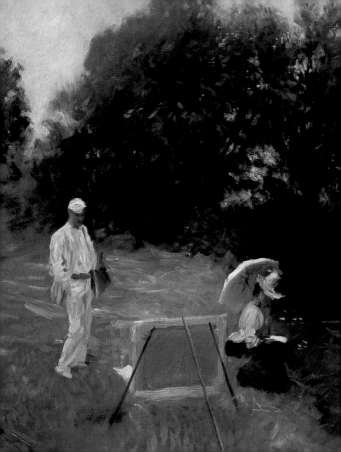

DENNIS MILLER BUNKER PAINTING AT CALCOT, 1888

ISABELLA STEWART GARDNER, 1922

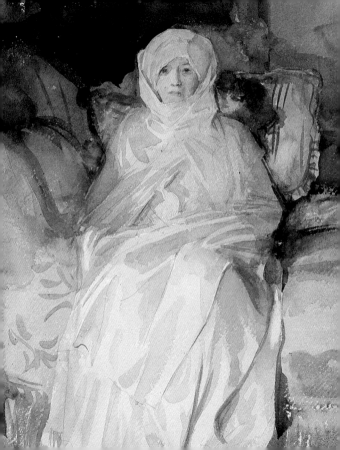

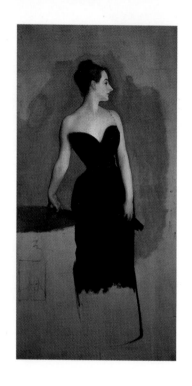

MADAME GAUTREAU (UNFINISHED COPY), c. 1884

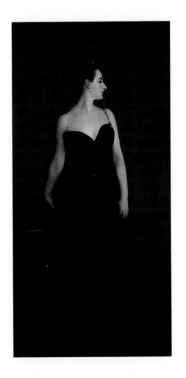

MADAME X (MADAME PIERRE GAUTREAU), 1884

PAUL HELLEU SKETCHING WITH HIS WIFE, 1889
(DETAIL AND OVERLEAF)

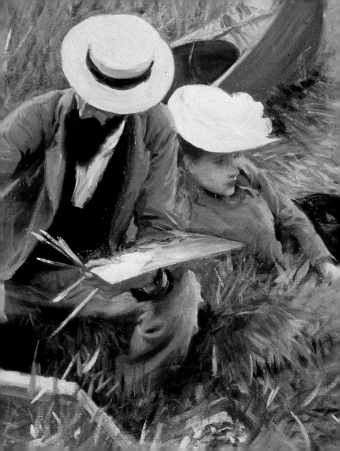

Every evening after dinner Charlotte Stant played to him; seated at the piano and requiring no music she went through his 'favourite things' – and he had so many favourites – with a facility that never failed, or that failed but just enough to pick itself up at a touch from his fitful voice. She could play anything, she could play everything – always shockingly, she of course insisted, but always, by his own vague measure, very much as if she might, slim, sinuous and strong, and with practised passion, have been playing lawn-tennis or endlessly and rhythmically waltzing.

The Golden Bowl, 1904

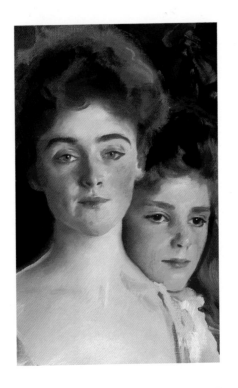

MRS FISKE WARREN AND HER DAUGHTER RACHEL, 1903 (DETAIL)

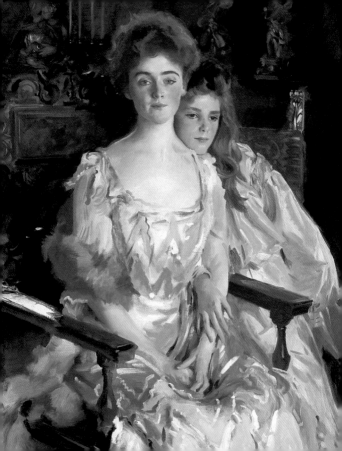

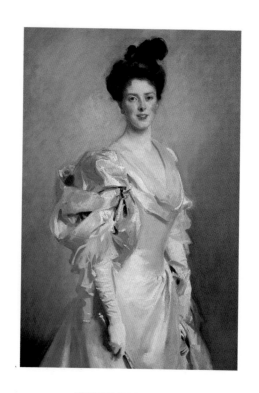

MRS JOSEPH CHAMBERLAIN, 1902

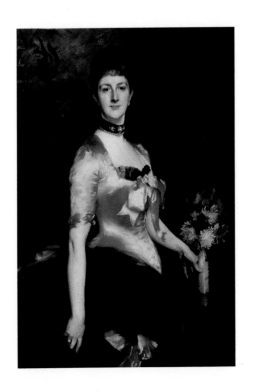

EDITH, LADY PLAYFAIR, 1884

MRS CARL MEYER AND HER CHILDREN, 1896

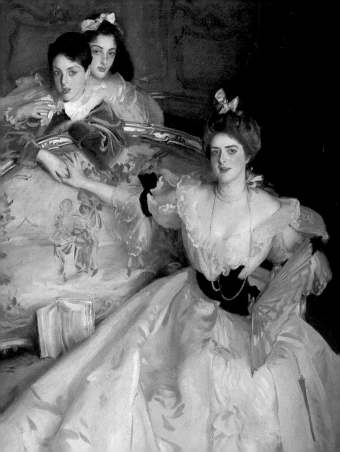

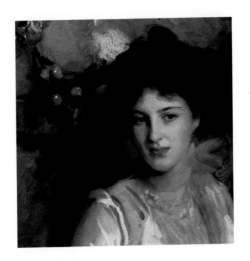

THE ACHESON SISTERS, 1902 (DETAIL)

THE ACHESON SISTERS, 1902

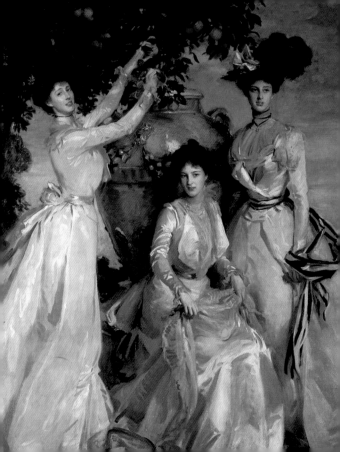

Mrs Assingham contrived, after a couple of pieces, to convey to her friend that, for her part, she was moved – by the genius of Brahms – beyond what she could bear; so that, without apparent deliberation she had presently floated away at the young man's side to such a distance as permitted them to converse without the effect of distain.

The Golden Bowl, 1909

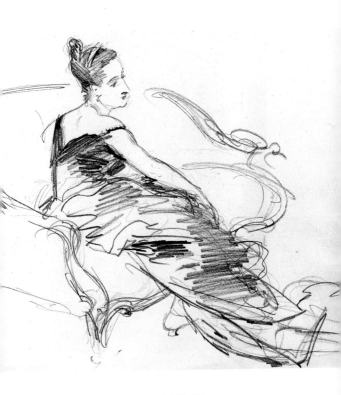

MADAME GAUTREAU, c. 1884

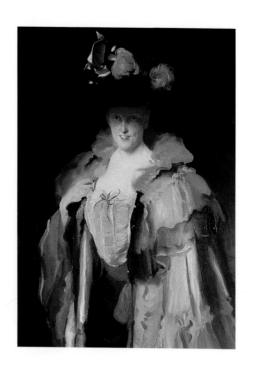

MRS CHARLES HUNTER, 1898

[Mrs Assingham] wore yellow and purple because she thought it better, as she said, while one was about it, to look like the Queen of Sheba than like a *revendeuse*; she put pearls in her hair and crimson and gold in her tea-gown for the same reason: it was her theory that nature itself had overdressed her and that her only course was to drown, as it was hopeless to try to chasten, the over-dressing. So she was covered and surrounded with 'things', which were frankly toys and shams, a part of the amusement with which she rejoiced to supply her friends.

The Golden Bowl, 1904

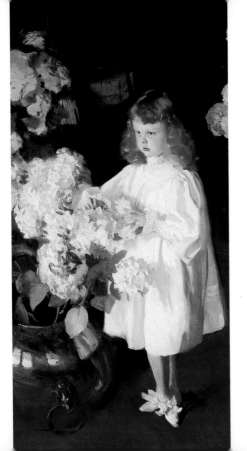

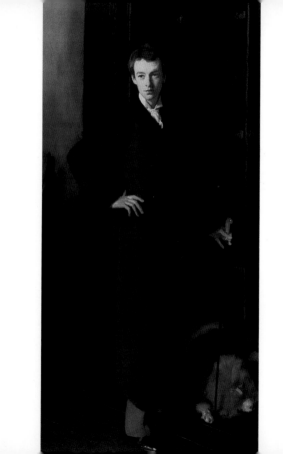

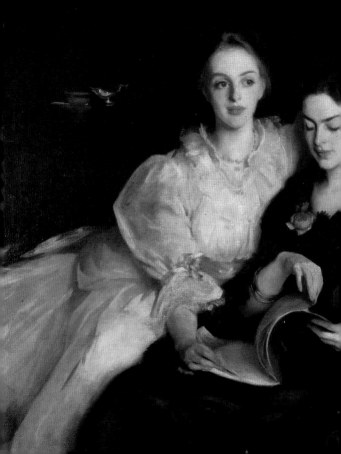

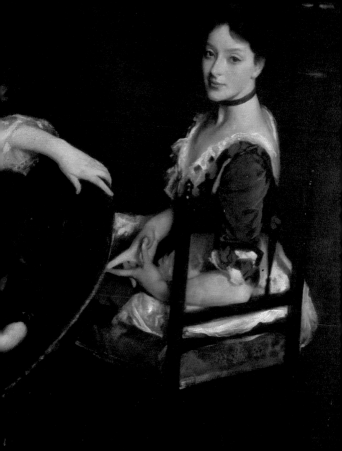

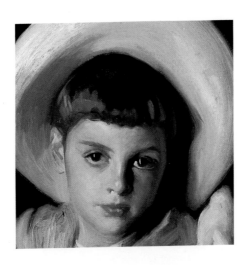

MRS EDWARD DAVIS AND HER SON LIVINGSTON, 1890
(DETAIL)

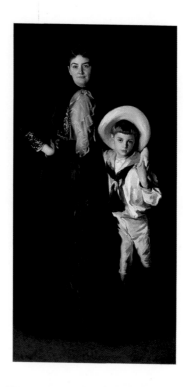

MRS EDWARD DAVIS AND HER SON LIVINGSTON, 1890

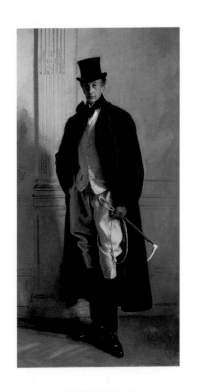

LORD RIBBLESDALE, 1902

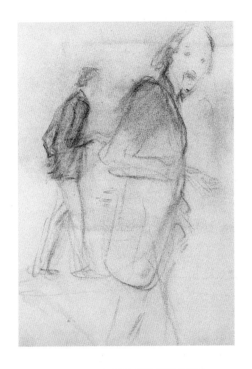

ROBERT LOUIS STEVENSON: TWO FIGURES, 1885

ROBERT LOUIS STEVENSON AND HIS WIFE, 1885 (OVERLEAF)

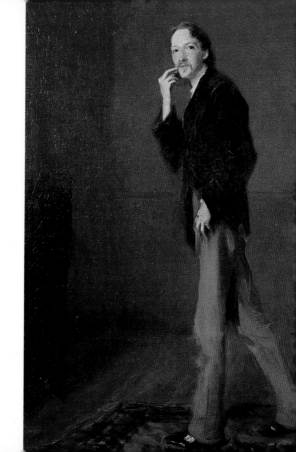

A MORNING WALK, c. 1888

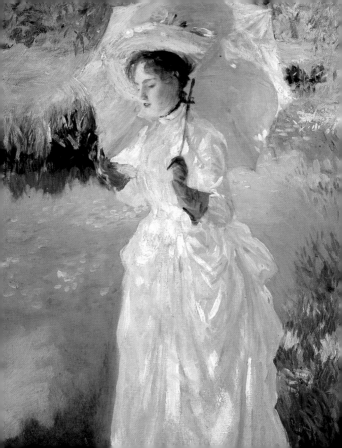

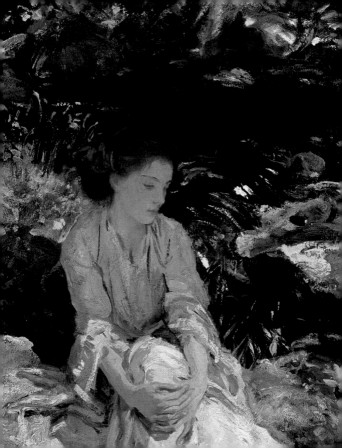

Kate had stature without height, grace without motion, presence without mass. Slender and simple, frequently soundless, she was somehow always in the line of the eye – she counted singularly for its pleasure. More 'dressed', often, with fewer accessories, than other women, or less dressed, should occasion require, with more, she probably couldn't have given the key to these felicities.

The Wings of the Dove, 1902

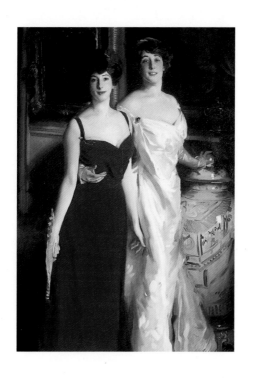

ENA AND BETTY, DAUGHTERS OF
MR AND MRS ASHER WERTHEIMER, 1901

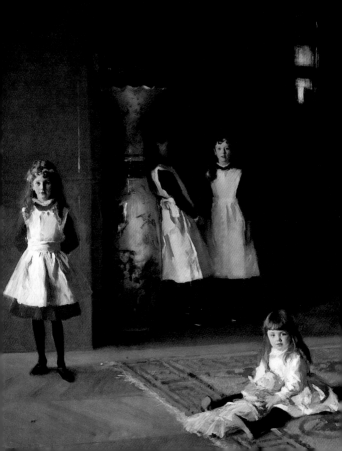

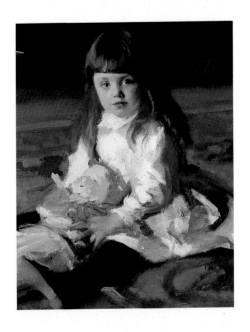

THE DAUGHTERS OF EDWARD D. BOIT, 1882

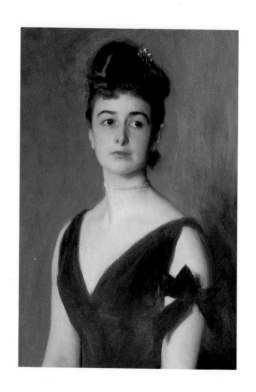

MRS CHARLES INCHES, 1887

[Milly] thrilled, she consciously flushed, and all to turn pale again, with the certitude – it had never been present – that she should find herself completely involved: the very air of the place, the pitch of the occasion, had for her both so sharp a ring and so deep an undertone. The smallest things, the faces, the hands, the jewels of the women, the sound of the words, especially of names, across the table, the shape of the forks, the arrangement of the flowers, the attitude of the servants, the walls of the room, were all touches in a picture and denotement in a play; and they marked for her moreover her alertness of vision. She had never, she might well believe, been in such a state of vibration; her sensibility was almost too sharp for her comfort...

The Wings of the Dove, 1902

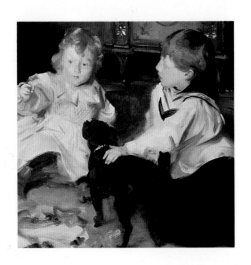

THE SITWELL FAMILY, 1900 (DETAIL AND OVERLEAF)

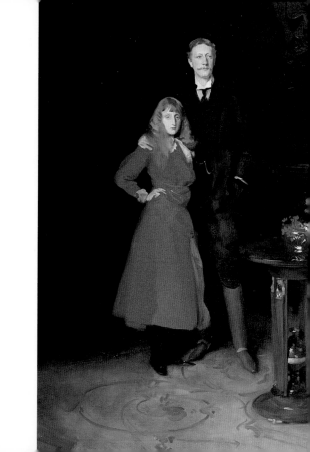

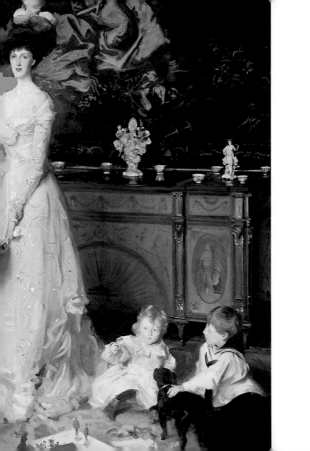

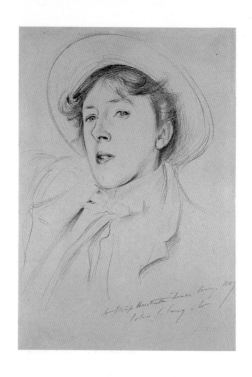

VERNON LEE, 1889

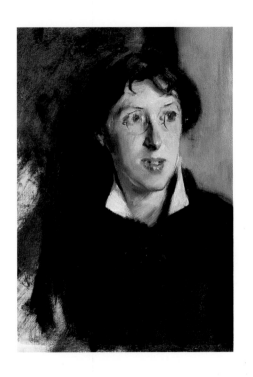

VERNON LEE, 1881

Hyacinth's imagination plunged again and again into the waves that whirled past it and round it, in the hope of being carried to some brighter, happier vision – the vision of societies in which, in splendid rooms, with smiles and soft voices, distinguished men, with women who are both proud and gentle, talked about art, literature and history.

The Princess Casamassima, 1886

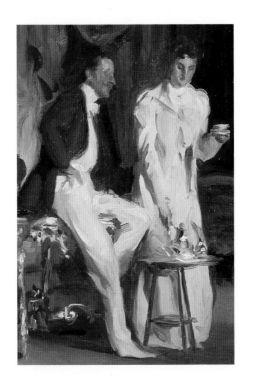

AN INTERIOR IN VENICE, 1899 (DETAIL AND OVERLEAF)

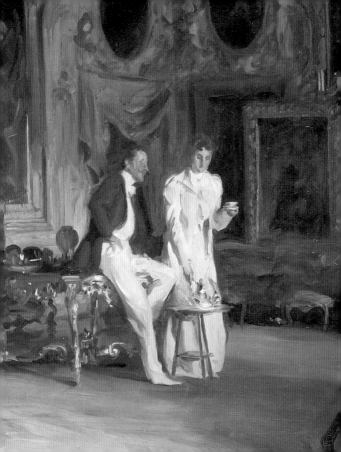

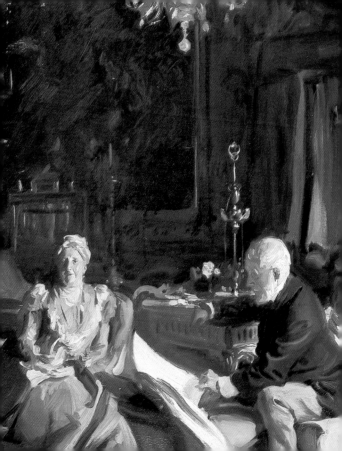

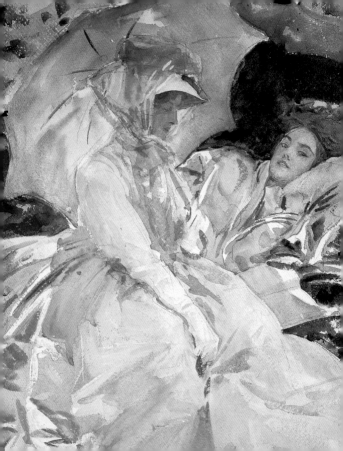

READING, 1911

BREAKFAST IN THE LOGGIA, 1910 (OVERLEAF)

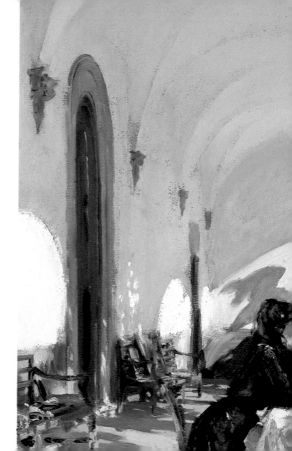

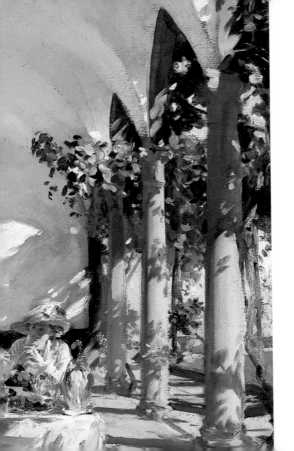

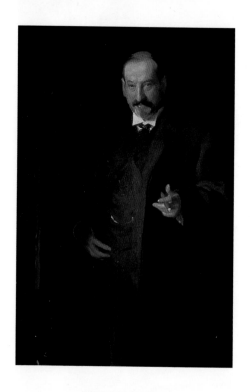

ASHER WERTHEIMER, 1898

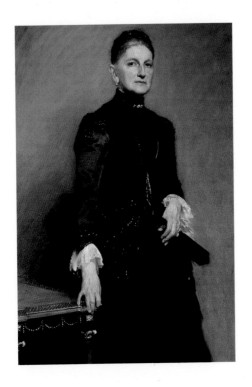

MRS ADRIAN ISELIN, 1888

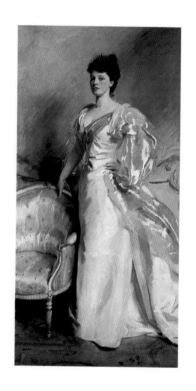

MRS GEORGE SWINTON, 1896-7

Her dark eyes, blue or grey, something that was not brown, were as sweet as they were splendid, and there was an extraordinary light nobleness in the way she held her head....Purity of line and form, of cheek and chin and lip and brow, a colour that seemed to live and glow.

The Princess Casamassima, 1886

THE MASTER AND HIS PUPILS, 1914

CLAUDE MONET PAINTING AT THE EDGE OF A WOOD, 1887-9
(OVERLEAF)

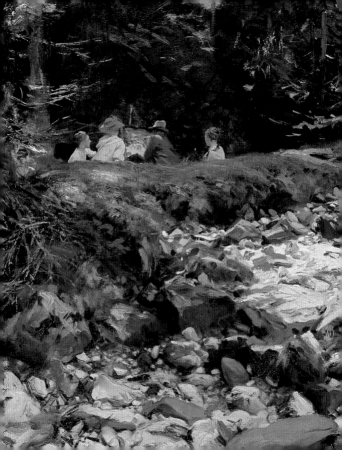

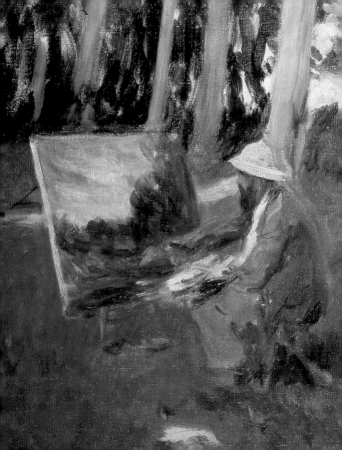

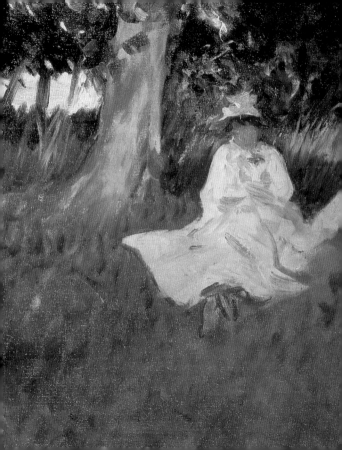

CAPRI, 1878

REPOSE, 1911 (OVERLEAF)

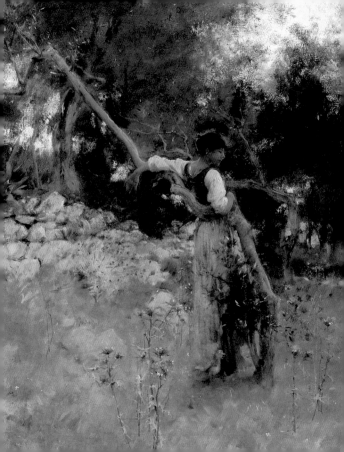

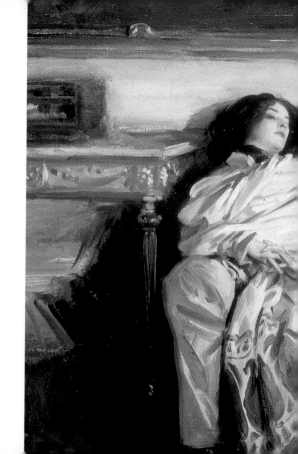

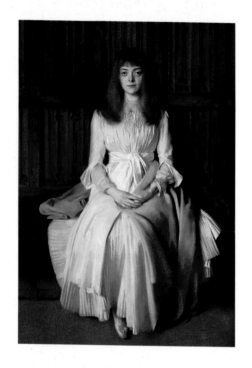

MISS ELSIE PALMER, 1889-90

BEATRICE TOWNSEND, c. 1882

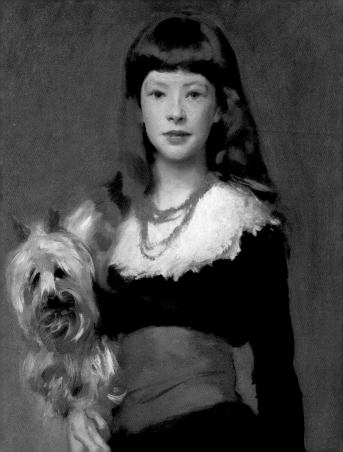

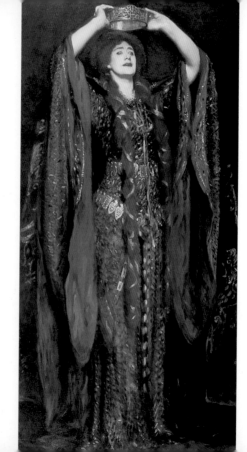

ELLEN TERRY (LADY MACBETH), 1889

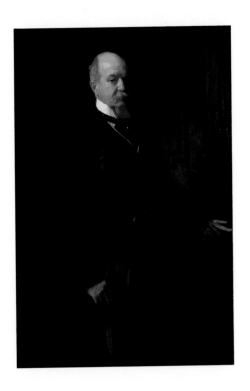

PETER A. B. WIDENER, 1902

What [the Prince] accordingly saw for some seconds with intensity was a tall strong charming girl who wore for him at first exactly the air of her adventurous situation, a reference in all her person, in motion and gesture, in free vivid yet altogether happy indications of dress, from the becoming compactness of her hat to the shade of tan in her shoes, to winds and waves and custom-houses, to far countries and long journeys, the knowledge of how and where and the habit, founded on experience, of not being afraid.

The Golden Bowl, 1904

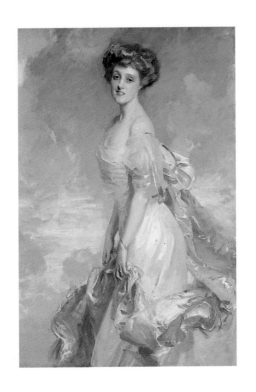

MATHILDE TOWNSEND, 1907

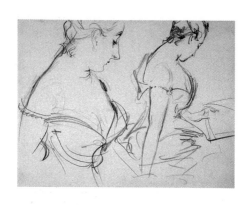

MADAME GAUTREAU (TWO STUDIES), c. 1883

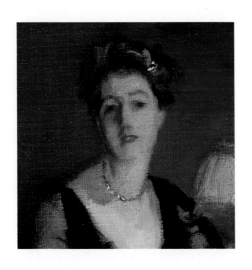

THE DINNER TABLE AT NIGHT (THE GLASS OF CLARET), 1884
(DETAIL AND OVERLEAF)

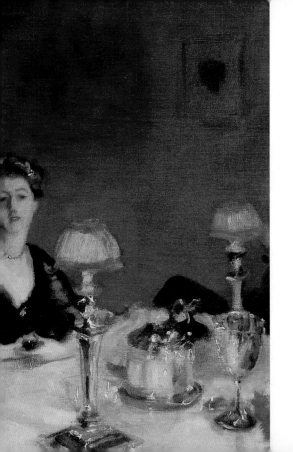

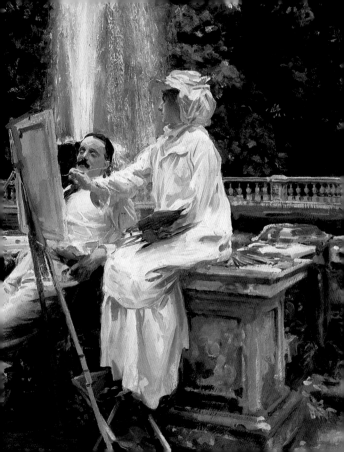

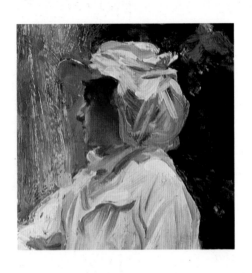

THE FOUNTAIN, VILLA TORTONIA, FRASCATI, ITALY, 1907

MOSQUITO NETS, 1908 (OVERLEAF)

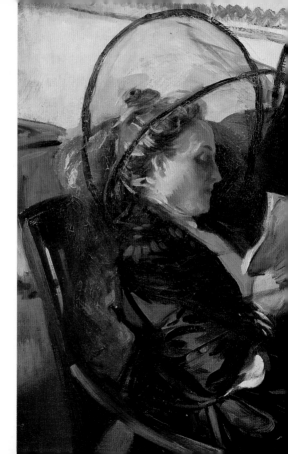

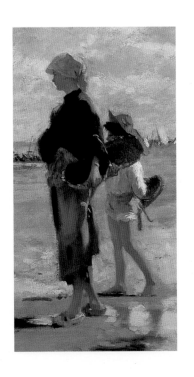

THE OYSTER GATHERERS OF CANCALE, c. 1878
(DETAIL AND OVERLEAF)

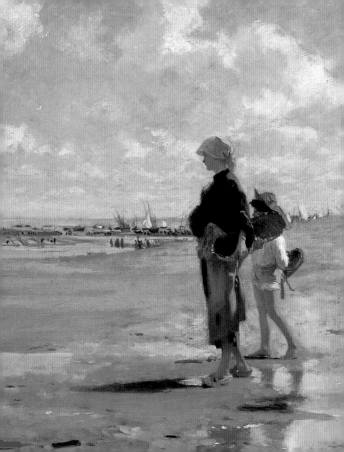

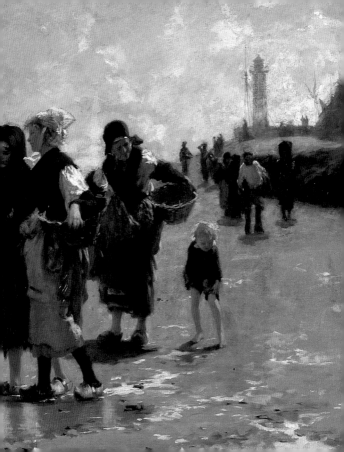

[Strether] had sent Maria Gostrey a word early, by hand, to ask if he might come to breakfast; in consequence of which, at noon, she awaited him in the cool shade of her little Dutch-looking dining-room. This retreat was at the back of the house, with a view of a scrap of old garden that had been saved from modern ravage; and though he had on more than one other occasion had his legs under its small and peculiarly polished table of hospitality, the place had never before struck him as so sacred to pleasant knowledge, to intimate chat, to antique order, to a neatness that was almost August.

The Ambassadors, 1903

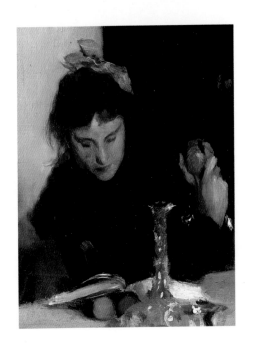

THE BREAKFAST TABLE, c. 1883-4 (DETAIL)

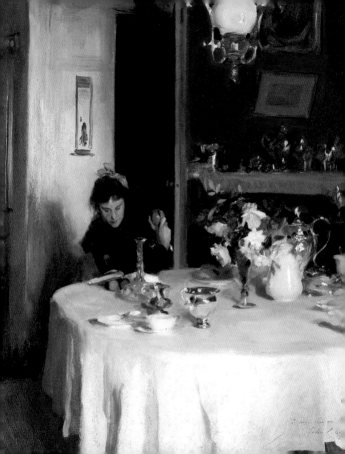

THE BREAKFAST TABLE, c. 1883-4

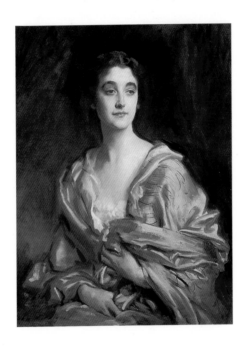

THE MARCHIONESS OF CHOLMONDELEY, 1913

This gentleman stands up in his brilliant red gown
with the presence of a princely Van Dyck.
Picture and Text, 1893

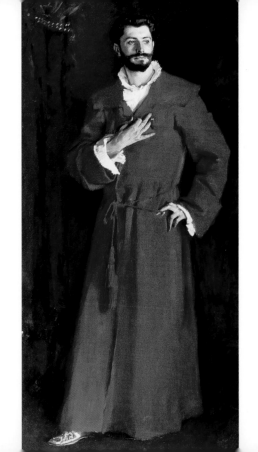

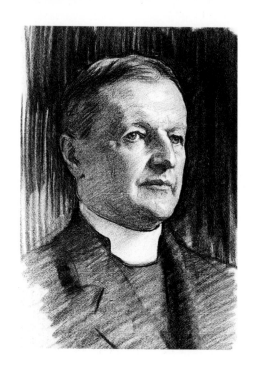

THE RT. REVEREND WILLIAM LAWRENCE, 1916

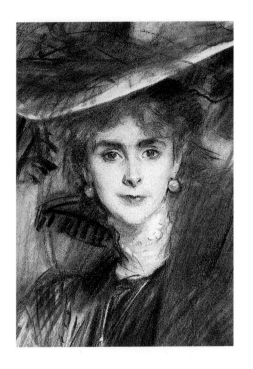

BARONESS DE MEYER, c. 1910

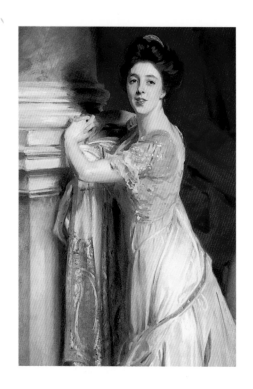

IZME VICKERS, 1907

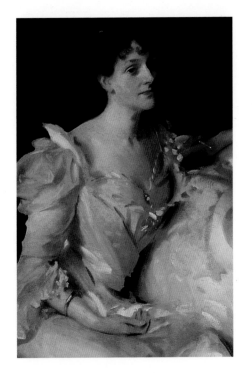

THE WYNDHAM SISTERS, 1899
(DETAIL)

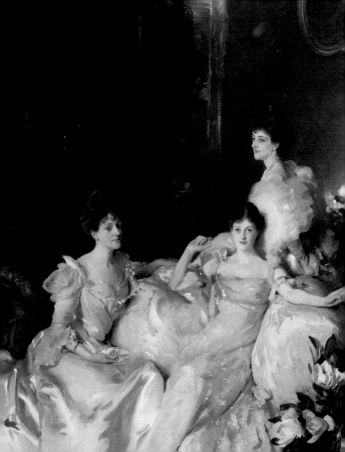

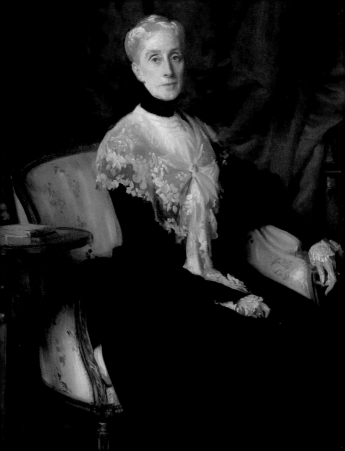

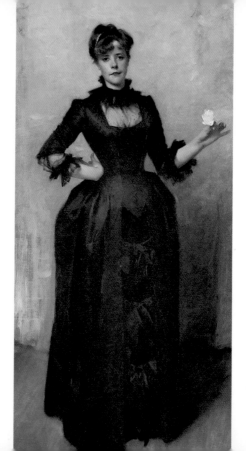

It is not only a portrait, but a picture, and it arouses even in the profane spectator something of the painter's sense, the joy of engaging also, by sympathy, in the solution of the artistic problem.

Picture and Text, 1893

LADY WITH ROSE (CHARLOTTE LOUISE BURCKHARDT), 1882

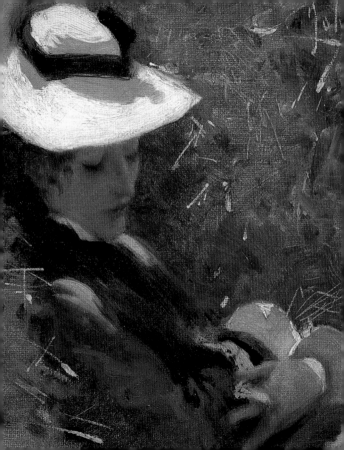

RESTING, c. 1875

THE SKETCHERS, 1914 (DETAIL AND OVERLEAF)

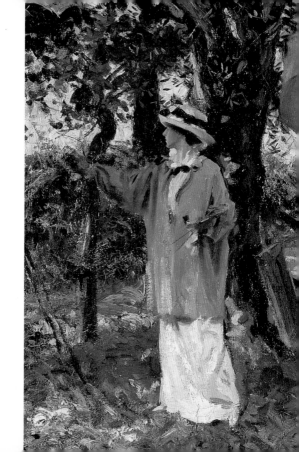

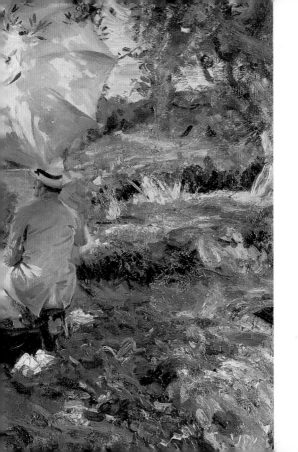

In the Luxembourg Gardens Strether pulled up;
here at last he found his nook, and here, on a penny
chair from which terraces, alleys, vistas, fountains,
little trees in green tubs, little women in white caps
and shrill little girls at play all sunnily 'composed'
together, he passed an hour in which the cup of
his impressions seemed truly to overflow.

The Ambassadors, 1903

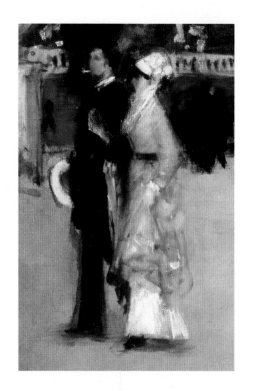

LUXEMBOURG GARDENS AT TWILIGHT, 1879
(DETAIL AND OVERLEAF)

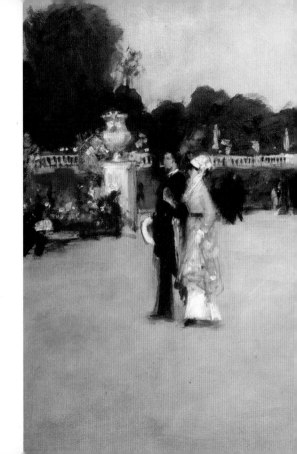

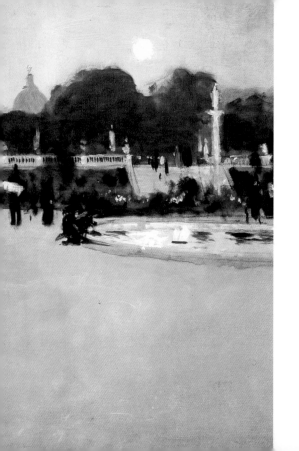

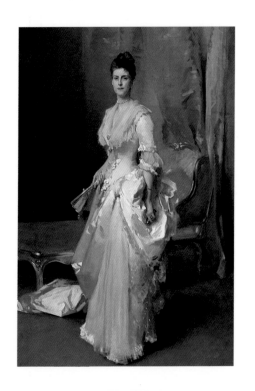

MRS HENRY WHITE, 1883

STUDY OF MRS ISAAC NEWTON PHELPS STOKES, c. LATE 1880s

MR AND MRS ISAAC NEWTON PHELPS STOKES, 1897

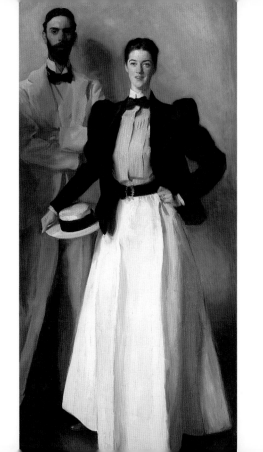

Mrs Lowndes was London, was life – the roar of the siege and the thick of the fray. There were some things, after all, of which Britannia was afraid, but Aunt Maud was afraid of nothing – not even, it would appear, of arduous thought.

The Wings of the Dove, 1902

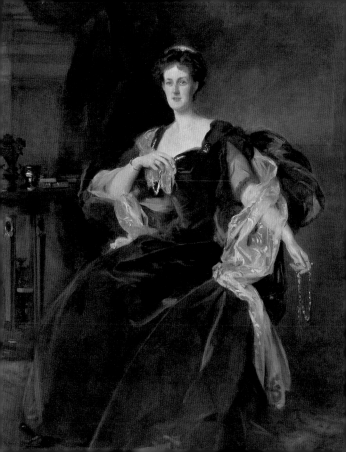

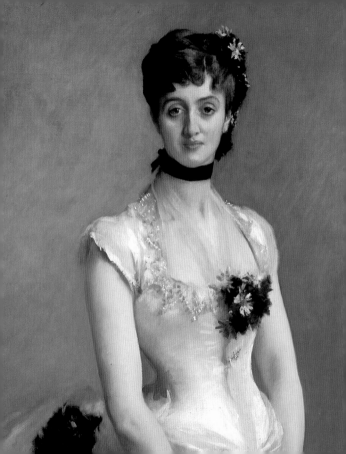

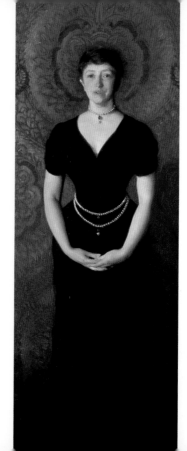

[The Prince] knew above all the extraordinary fineness of her flexible waist, the stem of an expanded flower, which gave her a likeness also to some long loose silk purse, well filled with gold-pieces, but having been passed empty through a finger-ring that held it together.

The Golden Bowl, 1904

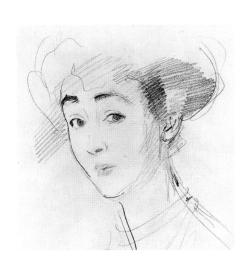

THE DUCHESS OF MARLBOROUGH, AFTER 1905

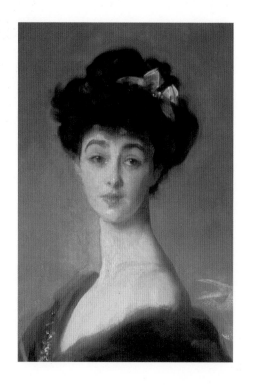

THE MARLBOROUGH FAMILY, 1905 (DETAIL)

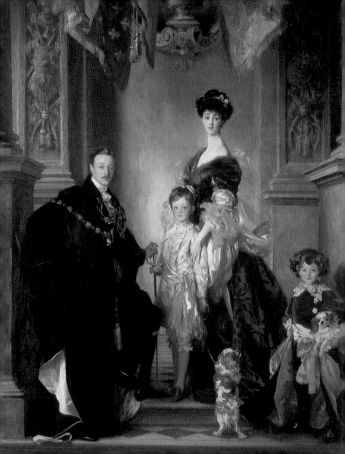

THE MARLBOROUGH FAMILY, 1905

MADAME GAUTREAU DRINKING A TOAST, 1882 (OVERLEAF)

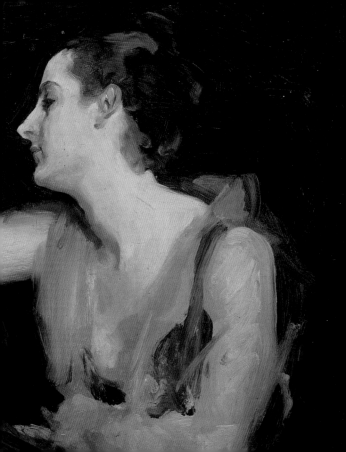

Born in Florence on 12 January 1856, John Singer
Sargent was a member of the American plutocracy
abroad. His parents, though natives of Philadelphia,
had chosen to forsake middle-class domesticity in
the States for a peripatetic existence on the
continent. Their summers were spent in northern
Europe, their winters in Italy and the warm south. It
must have been a rather unsettling and insecure life
– Sargent's parents had money but they were not
wealthy – and yet the fascinating mixture of sights
and sounds to which Sargent and his two sisters,
Emily and Violet, were exposed seems to have had a
significant impact. Much of their time was spent
sightseeing and becoming acquainted with the towns
in which they found themselves. Their father had an
enlightened attitude to education and learning and
believed that it should be about enjoyment and
interest and should not be regarded simply as a duty.
Their mother, who was a lively and spirited
character, also urged her children to look around
them and helped them to develop their sense of taste
and their eye for observation.

Mrs Sargent was an enthusiastic amateur sketcher
and thus responsible for fostering her son's early
impulses. Dating from about 1868 onwards, a fairly
extensive collection of careful studies of

architecture, armour, plants and birds survives. None of them display any particular skill or even hint at the genius who was to emerge later but they all possess a certain charm and individuality. When the time came for a career path to be chosen it was lucky for Sargent that the circles in which he was moving included artists willing to support him and to persuade his parents that a career as an artist would not be so terrible. Eventually his father was forced to forget his hopes of having a son in the navy and to accept that he needed to try out a less conventional lifestyle. In 1884 Sargent moved to Paris where he was accepted into the atelier of Carolus-Duran. Here, and at the Ecole des Beaux-Arts, he was to receive a training that would set him on course to becoming one of the most acclaimed portraitists of his era.

In the 1880s Carolus-Duran was regarded as a modernist. One of his trademarks was the importance he placed on the value of tone and the use of tonal relationships to create a realistic impression. His school of painting had some affinities with the Impressionists but its chief hero was Velázquez who, with his sense of grandeur and gravitas, was seen as one of the greatest masters. Sargent took his formal training very seriously. He borrowed some of Velázquez's compositional ideas, such as figures emerging from darkness into light,

and studied the way in which he built up characterization and conveyed mood to such effect. Even later on in his career Sargent continued to regard Velázquez, Frans Hals and Carolus-Duran himself as key figures. In 1878 Sargent won a second-class medal at the Salon for his *Oyster Gatherers of Cancale*, a painting full of light and atmosphere which drew gasps of admiration from the crowds who gathered. As a result of this prize, and of his first official portrait commission, Sargent was able to set up an independent practice in his own studio.

Edward Pailleron, a prominent playwright and author, was one of his first patrons. Sargent's portrait of Madame Pailleron received acclaim at the Salon of 1880 and was widely talked about for its dashing style and originality. With such early successes as this, it did not take long for Sargent to establish himself within Parisian society and to earn a reputation as a sophisticated young man about town who had a compulsion to paint. However, he still had to work hard to build up a stable list of clients. He found it difficult initially to break into the world of official patronage and to lure sitters away from well-established studios. At first most of his commissions came from wealthy Americans living in Paris or travelling through as part of their 'Grand Tour'. Although it was generally regarded as fitting neatly into the familiar genre of fashionable French

portraiture, Sargent's work did display occasional, rather surprising, avant-garde touches. It was this unconventional side to his style which caused outrage at the 1884 Salon where he exhibited his portrait of Madame Gautreau, an arresting Parisian beauty. The critics went wild. They accused Sargent of portraying Madame Gautreau, now renamed 'Madame X', as an amoral and brazen woman, of raising questions about her respectability and exposing her, both literally and figuratively, to the critical gaze of the public.

The scandal, although fierce, was short-lived but it seems to have been one of the main reasons why Sargent spent much of 1884 in England. Another was that he enjoyed the lively London social life and the company of his close friend Henry James, who was determined not to let him return to Paris. A significant advantage of staying in London was that there seemed to be no shortage of commissions, mostly from personal friends such as the Vickers family. The summer of 1885 was passed in the artists' village of Broadway in the Cotswolds where he delighted in the fresh air and the rural landscape and painted a picture entitled *Carnation, Lily, Lily, Rose*. This proved to be a great breakthrough in his career.

The charm and elegance of *Carnation, Lily, Lily, Rose* led to a series of new patrons and increased interest in this young portrait painter with his

attractive sense of European chic. Americans in particular seemed to appreciate Sargent's style and, when he visited New York in 1887, he was treated as a minor celebrity. From this time on, Sargent's career was launched. He made England his home, but spent some time in the States where he was commissioned to paint the murals decorating the upper landing of Boston Public Library. The subject was the development of religious thought and the murals show a series of worthy historical figures engaged in worthwhile pursuits. This work, which was to occupy him for the next twenty-five years, lacks the life and excitement of Sargent's portraiture but it did ensure that the artist remained a prominent figure and in the forefront of the public eye.

However, the growing bravura and confidence of Sargent's style would probably have been enough on their own to guarantee success. His elegant and incisive characterization means that the sitters seem to come alive on the canvas. From the grandeur and emotion of Ellen Terry as Lady Macbeth to the life and vigour of Joseph Jefferson, Sargent's skill lies in his ability to capture qualities in his sitters that draw the viewer in. In comparison, the work of his rivals looks dull and lacklustre. He saw his role as that of an image-maker, one who specialized in emphasizing personality in his male portraits and creating an impression of elegance and splendour in his female

portraits. It is for his female portraits that Sargent is best known. He saw the importance of costume and accessories when painting women, seemed to understand how to intensify certain characteristics while suppressing others and knew how to flatter without deceiving. And yet not every reaction to his work was favourable. D.S. McColl wrote of Sargent's 'cold accusing eye bent on the world' and some saw his work as formal and artificial. But the commissions kept coming in.

In 1894, prompted by the praise accorded to his portrait of Lady Agnew, Sargent was elected an Associate of the Royal Academy. His success at the Royal Academy was phenomenal; by 1897 he had become the most acclaimed portraitist since Sir Thomas Lawrence. Some of this success must be due to the fashions of the day. Sargent's approach was in tune with the current aesthetic tastes. Not only was portraiture in general in the ascendant but Sargent's work also displayed the influence of current stylistic preoccupations, such as Impressionism. A great admirer of Monet, Sargent liked to try out new ideas and experiment with different techniques. However, in the middle years of his career he often did not have the time. The extent of his commissions meant that he could not vary his style much. Never regarded as a real radical, he soon became completely alienated from the avant-garde, who saw

him as a frivolous, fashionable figure who painted by the rules and depended for his living on receiving commissions from his friends.

It did not take long for Sargent to tire of the constant round of society events and formal portraits. By 1900 his official portraits had become dignified, bland and politically correct. Few of his sitters seemed to arouse any spark of personal feeling or enthusiasm in him and he began to speak of his own work as mere 'mugs and paughtraits' (*sic*). His future, and his fortune, assured, he returned to painting watercolours of landscapes, and spent long summer holidays in Europe where he could concentrate on the scenery and enjoy the freedom. He began to paint for his own pleasure again and to limit the amount of portrait work he took on.

Yet even Sargent, with his strong will and sense of independence, could not ignore the First World War. He was appointed an official war artist and travelled to the front in France. The result was a large-scale painting entitled *Gassed*, a grimly atmospheric piece conveying something of life in the trenches. Shortly after the war Sargent was commissioned to paint a huge painting of the war generals for the National Portrait Gallery. A long, ritualized frieze, this work shows that his portrait skills were still active but his imagination was not necessarily engaged. During the last years of his life

his attention was focused mainly on the Boston murals. Having finished the Library murals, he took on the decorative work for the Boston Museum of Fine Arts and this occupied much of his time. When John Singer Sargent died on 14 April 1925, his death was an event of national significance. He was acclaimed as the greatest portraitist of his time and mourned on both sides of the Atlantic. It was said that he had treated the world as an occasion for art.

LIST OF PLATES

Miss Helen Sears, 1895. Oil on canvas, 167 x 90.8 cm. Museum of Fine Arts, Boston.

W. Graham Robertson, 1894. Oil on canvas, 245.7 x 205.1 cm. Tate Gallery, London.

The Misses Vickers, 1884. Oil on canvas, 137.1 x 182.9 cm. Graves Art Gallery, Sheffield/Bridgeman Art Library.

Mrs Edward Davis and her Son Livingston, 1890. Oil on canvas, 219.1 x 104.8 cm. Los Angeles County Museum of Art.

Lord Ribblesdale, 1902. Oil on canvas, 258.4 x 143.5 cm. National Gallery, London.

Robert Louis Stevenson: Two Figures, 1885. Pencil on paper, 24.7 x 34.2 cm. Fogg Art Museum, Harvard University Art Museums. Gift of Mrs Francis Ormond.

Robert Louis Stevenson and his Wife, 1885. Oil on canvas, 52 x 62.2 cm. Private collection.

A Morning Walk, c. 1888. Oil on canvas, 66.7 x 50.2 cm. Frick Art Reference Library, New York. Coe Kerr Gallery, New York.

The Black Brook, c. 1908. Oil on canvas, 55.2 x 69.9 cm. Tate Gallery, London.

Ena and Betty, Daughters of Mr and Mrs Asher Wertheimer, 1901. Oil on canvas, 185.4 x 130.8 cm. Tate Gallery, London.

The Daughters of Edward D. Boit, 1882. Oil on canvas, 221 x 221 cm. Museum of Fine Arts, Boston. Gift of Mary Louisa Boit, Florence D. Boit, Jane Hubbard Boit, and Julia Overing Boit in memory of their father, Edward Darley Boit.

Mrs Charles Inches, 1887. Oil on canvas, 86.4 x 61 cm. Museum of Fine Arts, Boston.

The Sitwell Family, 1900 . Oil on canvas, 170.2 x 193 cm. Renishaw Hall, Derbyshire.

Vernon Lee, 1889. Pencil on paper, 33.6 x 22.8 cm. Ashmolean Museum, Oxford.

Vernon Lee, 1881. Oil on canvas, 53.3 x 43.2 cm. Tate Gallery, London.

An Interior in Venice, 1899. Oil on canvas, 63.5 x 80 cm. Royal Academy of Arts, London/ Bridgeman Art Library.

Reading, 1911. Watercolour on paper, 50.8 x 35.6 cm. Museum of Fine Arts, Boston. Hayden Collection, Charles Henry Hayden Fund.

Breakfast in the Loggia, 1910. Oil on canvas, 52.1 x 71.1 cm. Freer Gallery of Art, Smithsonian Institution, Washington.

Asher Wertheimer, 1898. Oil on canvas, 147.3 x 97.8 cm. Tate Gallery, London/Bridgeman Art Library.

Mrs Adrian Iselin, 1888. Oil on canvas, 153.7 x 92.7 cm. National Gallery of Art, Washington.

Mrs George Swinton, 1896-7. Oil on canvas, 228.6 x 124.5 cm. Art

Institute of Chicago. Wirt D. Walker Collection.

The Master and his Pupils, 1914. Oil on canvas, 55.9 x 71.1 cm. Museum of Fine Arts, Boston.

Claude Monet Painting at the Edge of a Wood, 1887-9. Oil on canvas, 54 x 64.8 cm. Tate Gallery, London.

Capri, 1878. Oil on canvas, 76.8 x 63.5 cm. Museum of Fine Arts, Boston. Bequest of Helen Swift Nielson.

Repose, 1911. Oil on canvas, 63.5 x 76.2 cm. National Gallery of Art, Washington. Gift of Curt H. Reisinger.

Miss Elsie Palmer, 1889-90. Oil on canvas, 190.5 x 114.3 cm. Colorado Springs Fine Art Center.

Beatrice Townsend, c. 1882. Oil on canvas, 82.6 x 58.4 cm. Collection of Mr and Mrs Paul Mellon, Upperville, Virginia.

Ellen Terry (Lady Macbeth), 1889. Oil on canvas, 221 x 114.3 cm. Tate Gallery, London.

Peter A. B. Widener, 1902. Oil on canvas, 148.6 x 98.4 cm. National Gallery of Art, Washington. Widener Collection.

Mathilde Townsend, 1907. Oil on canvas, 153 x 102.2 cm. National Gallery of Art, Washington. Gift of the sitter, Mrs Sumner Welles.

Madame Gautreau (Two Studies), c. 1883. Charcoal on paper, 40.6 x 55.9 cm. British Museum, London.

The Dinner Table at Night (The Glass of Claret), 1884. Oil on canvas, 51.4 x 66.7 cm. Fine Arts Museums of San Francisco. Gift of the Atholl McBean Foundation.

The Fountain, Villa Tortonia, Frascati, Italy, 1907. Oil on canvas, 72.4 x 55.9 cm. Art Institute of Chicago. Friends of American Art Collection.

Mosquito Nets, 1908. Oil on canvas, 56.5 x 71.8 cm. Detroit Institute of Arts.

The Oyster Gatherers of Cancale, c. 1878. Oil on canvas, 78.7 x 123.2 cm. Corcoran Gallery, Washington.

The Breakfast Table, c. 1883-4. Oil on canvas, 55.2 x 46.4 cm. Fogg Art Museum, Harvard University Art Museums. Bequest of Grenville L. Winthrop.

The Marchioness of Cholmondeley, 1913. Oil on canvas, 86.4 x 67.3 cm. Marchioness of Cholmondeley/ Bridgeman Art Library.

Dr Pozzi at Home, 1881. Oil on canvas, 204.5 x 111.1 cm. UCLA at the Armand Hammer Museum of Art and Cultural Center, Los Angeles. The Armand Hammer Collection.

The Rt. Reverend William Lawrence, 1916. Charcoal on paper, 63.5 x 48.3 cm. National Gallery of Art, Washington. Gift of Right Reverend Frederic C. Lawrence.

Baroness de Meyer, c. 1910. Charcoal on paper, 71.1 x 33.7 cm. Birmingham Museums and Art Gallery.

Izme Vickers, 1907. Oil on canvas, 146.1 x 95.3 cm. Frick Art Reference Library, New York. Private collection.

The Wyndham Sisters, 1899. Oil on canvas, 292.2 x 214.6 cm. Metropolitan Museum of Art, New York.

Mrs William C. Endicott, 1901. Oil on canvas, 163.2 x 114.3 cm. National Gallery of Art, Washington. Gift of Louise Thoron Endicott, in memory of Mr and Mrs William Crowninshield Endicott.

Lady with Rose (Charlotte Louise Burckhardt), 1882. Oil on canvas, 213.4 x 113.7 cm. Metropolitan Museum of Art, Washington.

Resting, c. 1875. Oil on canvas, 21.6 x 26.7 cm. Sterling and Francine Clark Art Institute, Williamstown.

The Sketchers, 1914. Oil on canvas, 55.9 x 71.1 cm. Virginia Museum of Fine Arts. The Arthur and Margaret Glasgow Fund.

Luxembourg Gardens at Twilight, 1879. Oil on canvas, 73.7 x 92.7 cm. Institute of Arts, Minneapolis/Bridgeman Art Library.

Mrs Henry White, 1883. Oil on canvas, 221 x 139.7 cm. Corcoran Gallery, Washington. Gift of John Campbell White

Study of Mrs Isaac Newton Phelps Stokes, c. late 1880s. Pencil on paper, 23.5 x 15.2 cm. Fogg Art Museum, Harvard University Art Museums. Gift of Mrs Francis Ormond

Mr and Mrs Isaac Newton Phelps Stokes, 1897. Oil on canvas, 214 x 101 cm. Metropolitan Museum of Art, New York.

The Countess of Lathom, 1904. Oil on canvas, 228 x 200 cm. The Chrysler Museum of Art, Virginia. Gift of Walter P. Chrysler, Jr.

Madame Paul Poirson, 1885. Oil on canvas, 149.9 x 85.1 cm. Detroit Institute of Arts. Founders Society Purchase with funds from Mr and Mrs Richard A. Manoogian, the Beatrice Rogers Fund, Gibbs-Williams Fund and Ralph Harman Booth Bequest Fund.

Isabella Stewart Gardner, 1888. Oil on canvas, 189.9 x 80 cm. Isabella Stewart Gardner Museum, Boston

The Duchess Of Marlborough, after 1905. Pencil on paper, 28.6 x 19.7 cm. Metropolitan Museum of Art, New York

The Marlborough Family, 1905. Oil on canvas, 332.7 x 238.8 cm. By kind permission of His Grace the Duke of Marlborough.

Madame Gautreau Drinking a Toast, 1882. Oil on wood, 31.8 x 40.6 cm. Isabella Stewart Gardner Museum, Boston.

Phaidon Press Limited
Regent's Wharf
All Saints Street
London N1 9PA

First published 1996
Reprinted 1999
©1996 Phaidon Press
Limited

ISBN 0 7148 3544 7

A CIP catalogue record
for this book is available
from the British Library.

Printed in Hong Kong

PAGE 2
**CARNATION, LILY, LILY,
ROSE**, 1885-6

PAGE 3
STUDY FOR **CARNATION,
LILY, LILY, ROSE**, n.d